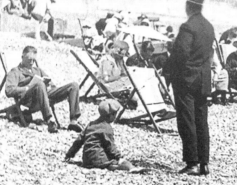

HYTHE
HISTORY TOUR

First published 2018

Amberley Publishing
The Hill, Stroud,
Gloucestershire, GL5 4EP
www.amberley-books.com

Copyright © Martin Easdown &
Linda Sage, 2018
Map contains Ordnance Survey data
© Crown copyright and database right
[2018]

The right of Martin Easdown &
Linda Sage to be identified as the
Authors of this work has been asserted
in accordance with the Copyrights,
Designs and Patents Act 1988.

ISBN 978 1 4456 8474 1 (print)
ISBN 978 1 4456 8475 8 (ebook)

British Library Cataloguing in
Publication Data.
A catalogue record for this book is
available from the British Library.

Origination by Amberley Publishing.
Printed in Great Britain.

INTRODUCTION

Hythe has managed to retain its charm as a small English town steeped in history and is one of the famous Cinque Ports. These are the group of coastal towns in Kent and East Sussex who were given their own rights and laws in medieval times in exchange for ensuring they – in the service of the monarch – provided a robust defence against foreign enemies and ships, as well as ensuring his safe passage across the English Channel. The town still possesses its charter granted by Edward I in 1278 (along with many fourteenth-century documents of historical significance), and its importance in those times is demonstrated by its impressive Norman church and range of medieval buildings.

However, Hythe hit upon hard times during the fourteenth and fifteenth centuries. The town was attacked by the French and was ravaged by the Black Death in 1348–49. Then in 1400 Hythe lost most of its fleet during a storm, many of its buildings through fire, and the plague returned. Worse still, the port was silting up and unable to keep to its commitment of supplying ships to the monarch. Yet Hythe retained some measure of importance, and in 1575 was granted a charter of incorporation by Elizabeth I, which enabled it to elect its own mayor and councillors and hold a fair. The town slumbered quietly for a time thereafter, acquiring some impressive Georgian buildings on the way and a classical-style Town Hall in 1794. Influential families such as the Deedes' and Tournays, who held the mayor's office forty-one times between them, held an exerting influence over Hythe between the mid-seventeenth century and early nineteenth century.

Hythe was brought back into the firing line with the threatened Napoleonic invasion in the first decade of the nineteenth century. As a result, the town acquired ten of the curious Martello defence towers and a section of the Royal Military Canal. Both the towers and gun points on the canal never fired a shot in anger (except perhaps against the active local smugglers!), but the sylvan beauty of the canal soon led it to become one of Hythe's greatest attractions. The School of Musketry (later the Small Arms School) also came to Hythe, and although that closed in the 1960s, the firing ranges remain in use for soldiers from nearby Shorncliffe Camp and ensure that, for now, the town still has a role to play in the defence of the realm.

Hythe's old-world charm as a Cinque Port and its position on the coast led to it becoming a popular, if modest, seaside resort. The first purpose-built amenity for visitors was an indoor bathhouse built in 1854 and the popularity of the resort increased with the opening of a station by the South Eastern Railway in 1874. The railway company helped to finance the building of a grand hotel (the Seabrook, later the Imperial Hotel) in 1880 and an extension of the promenade, although the development of the exclusive Seabrook Estate failed to take place. Marine Parade and West Parade were developed in the late 1870s and 1880s by the Corporation in association with private companies (demolishing some of the redundant Martello towers in the process) and were sporadically developed with accommodation, although further development had to wait until the 1920s and 1930s.

By the Edwardian period Hythe was attracting visitors who preferred a less boisterous type of watering place. The cumbersome bathing machines were giving way to bathing huts and donkeys provided rides along the promenade. The height of Hythe seaside fashion were the fairs, fêtes and donkey derbies held in the grounds of the Imperial Hotel – which liked to claim Hythe had the lowest death rate in England. Away from the beach,

there was the Venetian Fête and boating on the Royal Military Canal, the macabre collection of skulls and bones in the parish church crypt, the horse tram to Sandgate, tree-lined Ladies Walk, Hythe Cricket Week, the Hythe Town Band in the Grove Bandstand, concerts and a subscription library in the Institute and the charm of the old town climbing up the hill from the High Street. The first cinema came to Hythe in 1911 with the opening of the Hythe Picture Palace. In addition to tourism and servicing the military, the town's industries included brewing, milling and fishing.

Hythe continued to flourish as a resort during the interwar period when it acquired the world-famous Romney, Hythe & Dymchurch Railway in 1927 and was promoted by the Southern Railway as the 'Pride of Kent'. Two convalescent homes opened in that period: the Christian Holiday Fellowship at Moyle Tower in 1923 and Philbeach for London transport workers in 1924. They helped ensure that Hythe received a regular stream of visitors to enjoy its health-giving air. In 1937, Hythe gained an ultra-modern art deco cinema: the Ritz. Following the end of the Second World War, the resort was promoted as 'where the country meets the sea' but changing holiday patterns saw visitor numbers decline; however, Hythe has managed to retain its two large hotels, the Imperial Hotel and Stade Court. The 1960s and 1970s saw some changes in Hythe: the Mackeson Brewery and Small Arms School were closed and subsequently demolished, and other buildings fell victim to road widening. However, Hythe escaped the large-scale redevelopment of many towns and remains a pleasant town to both visit and live in, with a fascinating past to explore.

This tour of Hythe – which commences at the Romney, Hythe and Dymchurch station and ends at the Imperial Hotel, taking in the High Street, the Royal Military Canal and seafront along the way – will show you most of the town's historical landmarks, both extant and demolished. We hope you enjoy the walk and will find it a rewarding historical experience.

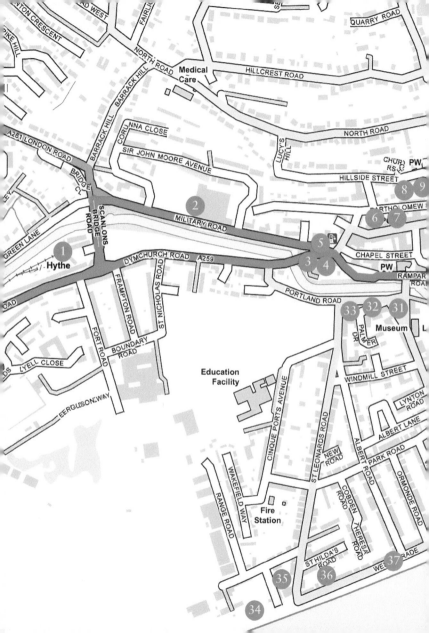

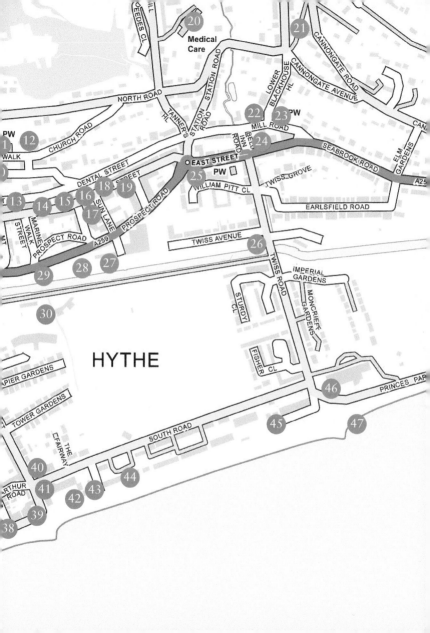

KEY

1. RH&DR

For many people, the mention of Hythe brings to mind the Romney, Hythe & Dymchurch Railway, one of the most famous and popular of all miniature railways. The line was largely the brainchild of Captain J. E. P. Howey, who engaged noted miniature railway engineer Henry Greenly to design all aspects of the railway, including the charming locomotives. Work began at New Romney in 1925 and the line was opened to Hythe on 16 July 1927.

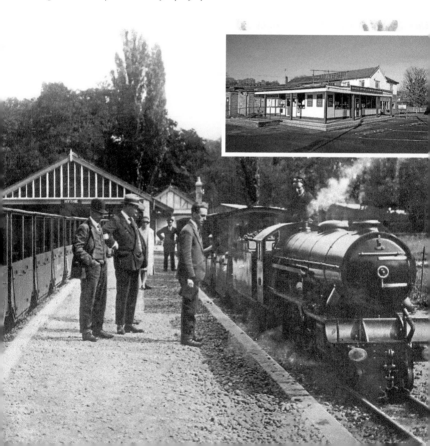

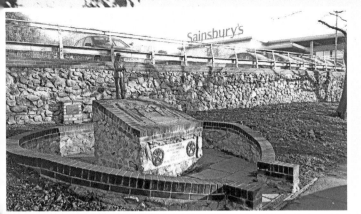

Hythe. School of Musketry.

2. SCHOOL OF MUSKETRY

The School of Musketry was built in 1805–10 during the threatened Napoleonic invasion, and until 1838 the barracks were occupied by the Royal Staff Corps. In 1853, the School of Musketry was transferred to Hythe to give training on the new Enfield rifle, and in 1919 it was renamed the Small Arms Wing. The school was closed in 1968 and the site is now occupied by Sainsbury's, although it is remembered in the charming memorial seen in the inset photograph.

3. OLD PORTLAND ARMS

The Old Portland Arms, seen here in the 1890s, is a long-lost beerhouse, having closed in 1905. The Swain family, who were licensees from 1881, can be seen posing for the photographer. The premises, which had public and private bars and nine bedrooms, was auctioned on 22 January 1906 at the Sessions Hall, Bank Street, and subsequently became Cowell's restaurant and Blackman's fish merchants before being extensively refurbished as the Red Lion Court block of apartments.

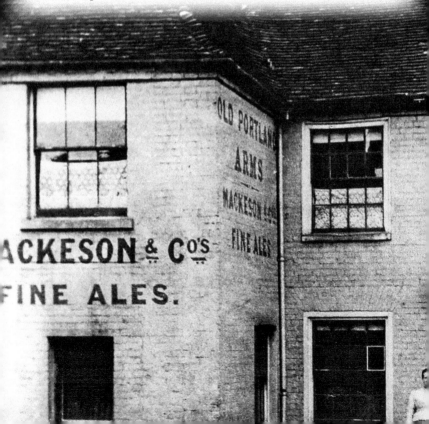

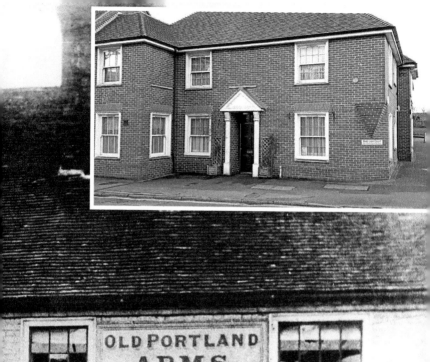

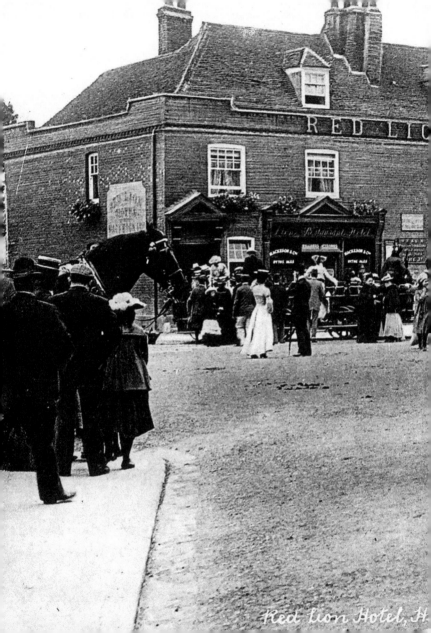

Red Lion Hotel, H.

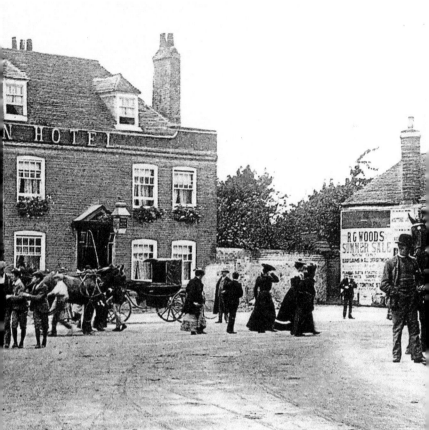

4. RED LION SQUARE

Red Lion Square was the terminus for both the horse tram and bus services to Hythe. A tram can be seen at the end of its run from Sandgate outside the Red Lion Hotel *c.* 1905. A competing horse bus can be seen on the right ready to depart for Folkestone. The Red Lion dates from the seventeenth century when it was known as the Three Mariners and still trades today, an era where many pubs are closing.

5. THE 'TOAST-RACK' TRAM AND MACKESON'S BREWERY

The 'Toast-rack' tram of the Hythe and Sandgate horse tramway stands in Red Lion Square *c.* 1910. The tramway opened in 1891–92 and closed on 30 September 1921. In the background is the famous Mackeson Brewery, producers of the renowned milk stout. Brewing ceased at the site in 1968 and it was closed completely five years later. In 1983 sheltered housing was built on the area and an attractive seating area has recently been created.

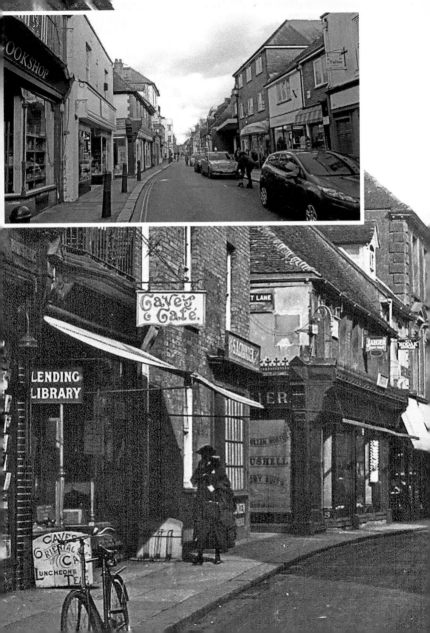

6. HIGH STREET (WESTERN END)

The western end of the High Street photographed in the 1920s. In the foreground on the left is Messrs Hall and Pursey booksellers and stationers and next to them is Cave's Café. Two doors along from them, in the low building with the steep roof (now Payden's chemist and the post office) is where the inventor of the steam screw propeller, Francis Petit-Smith, was born in 1808. A plaque commemorating this can be seen on the building.

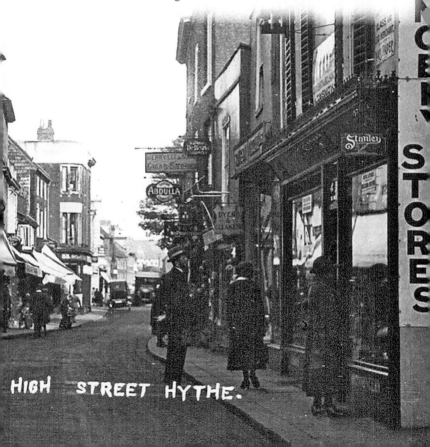

HIGH STREET HYTHE.

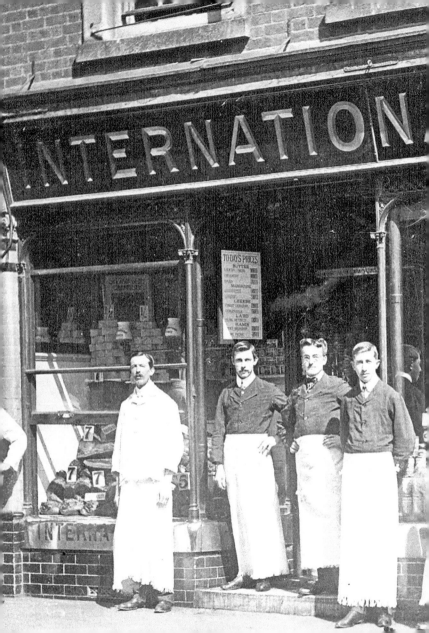

7. INTERNATIONAL STORES

The staff of International Stores proudly pose outside their shop at No. 157 (now Nos 43–45) High Street on this postcard sent in 1908 by one of those in the photograph – he is messaging to say he could not attend the flower show as promised. The Hythe branch opened in 1898 and remained at the premises until 1973 when it became an estate agents. The modern inset photograph shows the building is still used for that purpose.

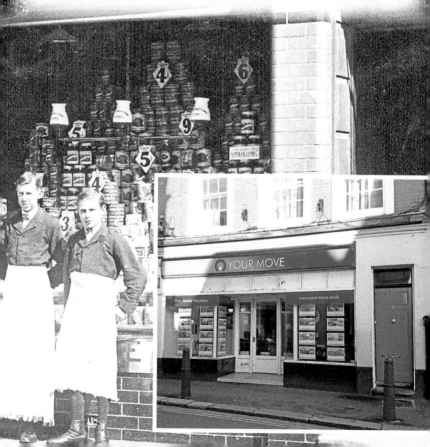

8. CENTURIES

A view looking west along Bartholomew Street in the 1920s. The medieval building on the right is St Bartholomew's Hospital (also known as Centuries), built of Kentish ragstone and established during the twelfth century as a poorhouse, which is now almshouses. The property next door is the Yeoman's House and the tall building to its left is Brewery Buildings, which once housed a pub called the Prince of Prussia (known as the New Portland Arms from 1875).

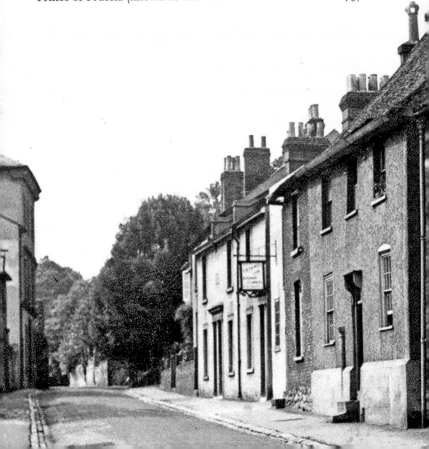

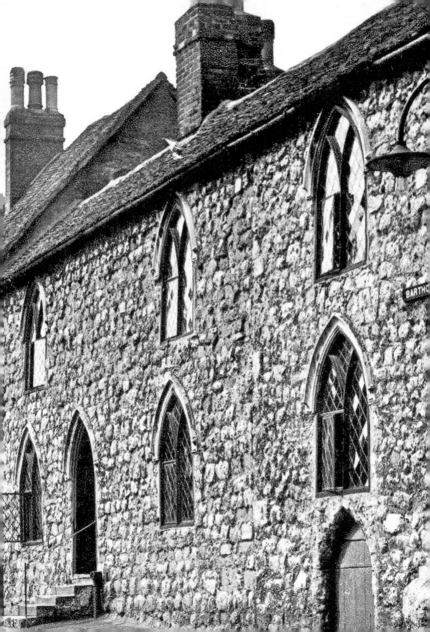

9. CHURCH HILL

Centuries, which was rebuilt in the fourteenth century, can be seen on the left of this 1920s postcard of Church Hill, which was formerly part of a busy thoroughfare from the old harbour to Saltwood Castle. Further up the hill a house can be seen with a plaque commemorating that the writer Elizabeth Bowen lived there between 1965 and 1973. Centuries continued to serve the less-fortunate people of the parish until 1949, when it was converted into dwellings.

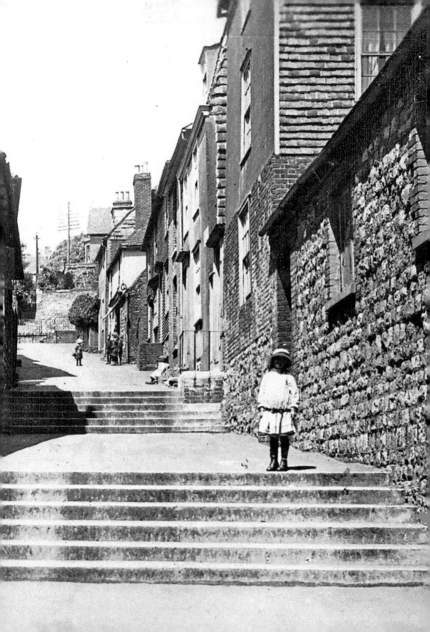

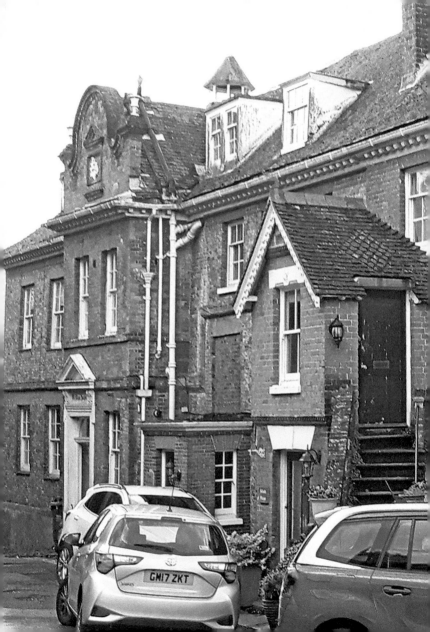

10. OLD MANOR HOUSE

Sited just below the main entrance to St Leonard's Church, the Manor House was erected in 1658 by John Deedes, who was three times mayor of Hythe, a Member of Parliament and captain of the Trained Hythe Volunteers. The Deedes family were one of the most influential in Hythe for many years and were mayors of the town twenty-two times between 1640 and 1795. The house, originally known as St Leonard's, was rebuilt in a Georgian style in 1785.

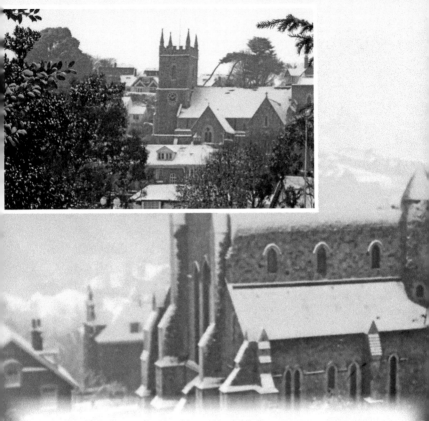

11. ST LEONARD'S CHURCH

Two views of St Leonard's Church in the snow – the main image is from 1909 and the inset is 2010. The church dominates the vista of the town and is noted for its high thirteenth-century chancel, built to almost cathedral-like proportions. The original Norman church was erected in 1090 and was considerably enlarged in 1175. During the thirteenth century, the church was restyled in the fashionable Early English style with the addition of a tower, choir and sanctuary and the raised chancel with ambulatory underneath.

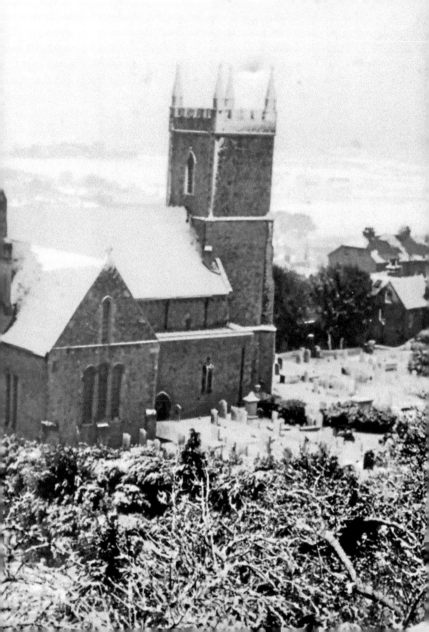

12. THE OSSUARY

The ambulatory, or crypt, underneath St Leonard's Church is a home to a macabre collection of 2,000 human skulls and 8,000 thigh bones. It has been established that they are medieval in origin, perhaps including some Black Death victims, and had been disinterred to make way for new graves. The Ossuary, or Bone House, is one of only two in the country and for a small charge this strange gathering of human relics can still be viewed today.

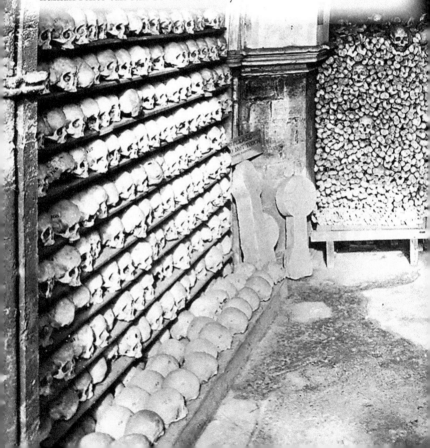

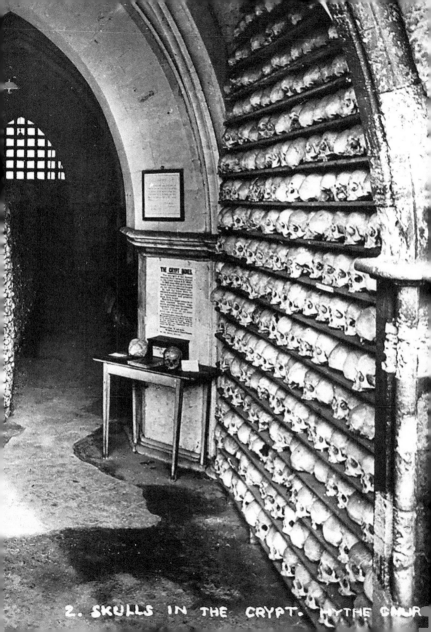

2. SKULLS IN THE CRYPT. HYTHE CHUR

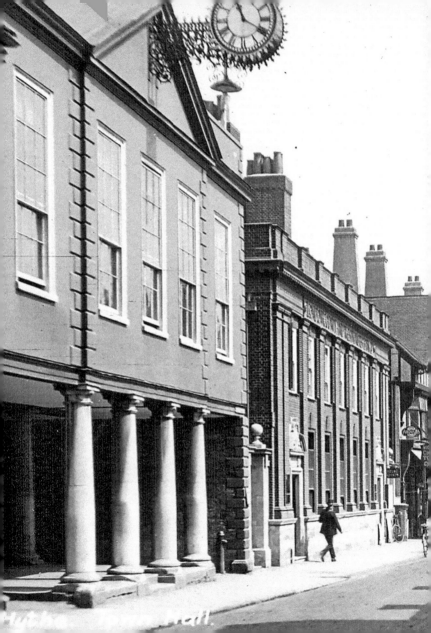

Hythe. Town Hall.

13. TOWN HALL

Hythe's Town Hall stands on the site of an old Court Hall and was erected in 1794 by bricklayer and stonemason William Tritton at a cost of £1,100. The classical-style building, with its Portland stone Tuscan columns, housed the courtroom (removed to Bank Street in 1881) and council chamber, along with a small holding gaol and market. The distinctive hanging clock was added by Henry Scott in 1871. The building is still used by Hythe Town Council.

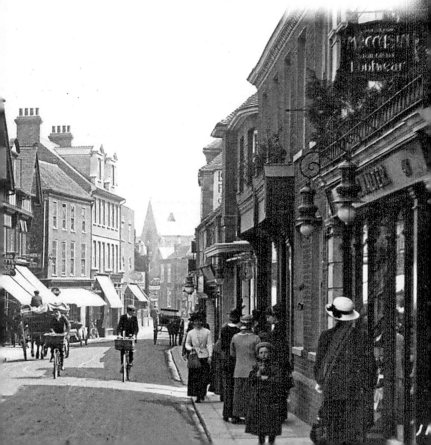

14. SMUGGLER'S RETREAT

The Smuggler's Retreat was a very distinctive and picturesque building in the High Street that was sadly demolished in 1907–08 despite last-minute efforts to save it. The building was erected in *c.* 1500 and the tower was reputedly used to house a lantern to signal to smugglers at sea. This view from around 1905 shows that it housed three shops: Miss E. Snashall's newsagents, George Wire, fishmonger and poulterer, and Alfred Snashall's confectionery and toy shop.

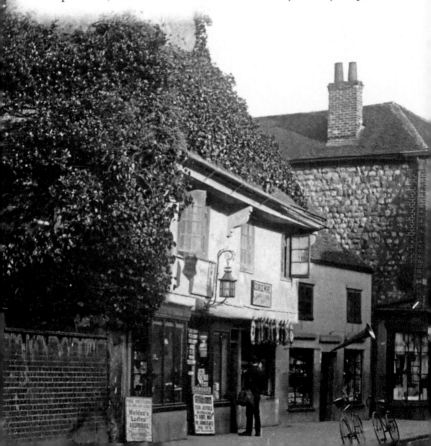

15. NEW SMUGGLER'S RETREAT

Following the demolition of the Smuggler's Retreat, these three shops were erected in 1908 in a mock-Tudor style and this postcard shows them newly built. They were termed the 'New Smuggler's Retreat', although they failed to match the charm of their predecessor. Charles Straughan's newsagents (left), Hythe Post Office (centre) and J. G. W. Harris, antique furniture (right) occupied the new shops. The New Smuggler's Retreat can still be seen in a largely unaltered condition.

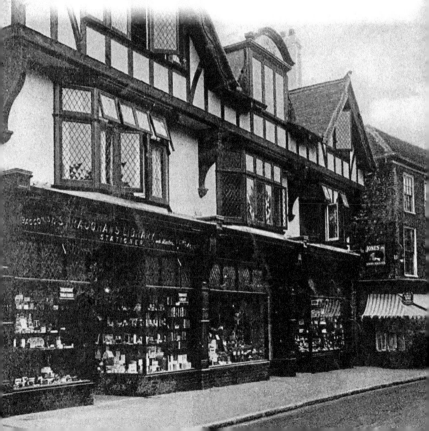

16. HIGH STREET (EASTERN END)

A postcard used in August 1912 looking towards the eastern end of the High Street, featuring the Coronation Tea Rooms and the Hythe Picture Palace, demolished in 1928 for an arcade of shops that were subsequently destroyed by a bomb in 1940. The Picture Palace was Hythe's first cinema and was opened on 12 April 1911 as the Hythe Electric Theatre. It was renamed the Hythe Picture Palace in May 1912. The junction with Theatre Street can be seen on the right.

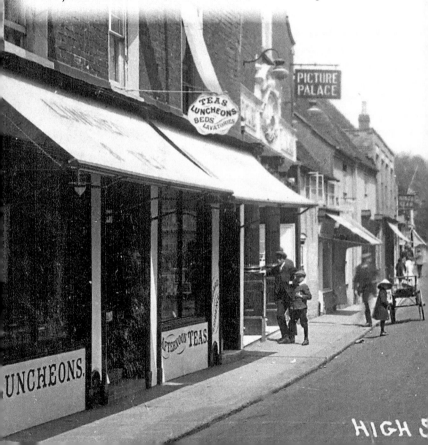

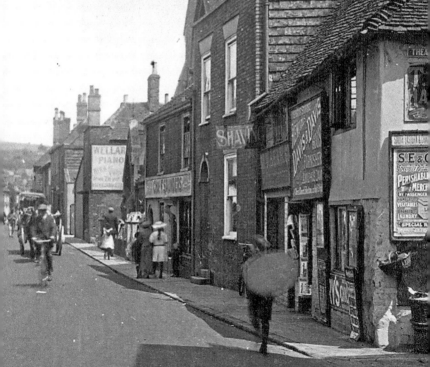

...TREET, HYTHE.

17. CONGREGATIONAL CHURCH

The Congregational Church in the High Street, seen here *c.* 1910 along with a group of girls posing for the photographer, was built in 1868 in Walnut Tree Yard at a cost of £2,500. In 1872 a small school was added, which was later used as the church hall. The church was demolished in 1987 upon the opening of the United Reformed Church in East Street and was replaced by a residential development called Walnut Tree Mews.

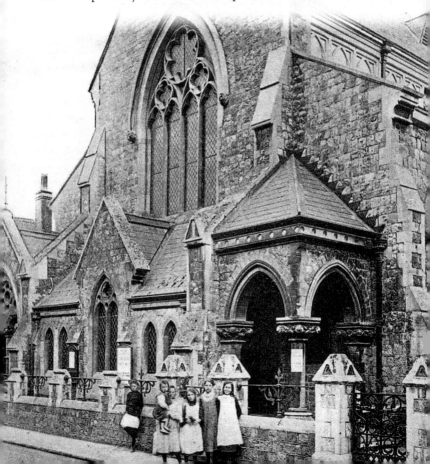

18. THE KINGS HEAD

The Kings Head is one of four inns to still trade in the High Street, the others being the Swan, White Hart and Globe. The inn was previously known as the George, and the Sun (remembered in Sun Lane opposite), before adopting the present designation in 1750, which gives its name to the lane at the side of the inn. From 1847 to 1899 The Kings Head was run by members of the File family, who also traded as carpenters and coopers.

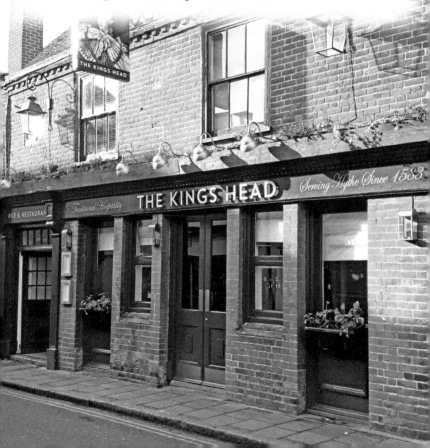

19. ST JOHN'S HOSPITAL

St John's Hospital was founded in the fourteenth century and the building seen here in the High Street was erected in sixteenth century, although it was extensively altered in 1802. In 1539 it was conveyed by the church to trustees for use as almshouses, to be run by the town's jurats, and in 1562 provided maintenance for eight of Hythe's needy. St John's has continued to carry out this worthwhile cause and currently has eight apartments.

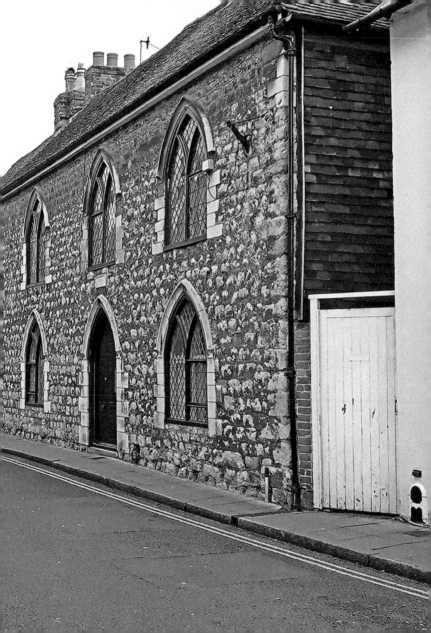

20. PHILBEACH

Originally constructed as a private home, Philbeach was opened as a convalescent home on 20 April 1925 by the TOT Mutual Aid Fund of London Transport Passenger Companies. An extension was opened in 1937 when the home had forty-two bedrooms, four lounges, a children's playroom, library and extensive grounds. Up to seventy female contributors to the fund could convalesce at the home along with twenty-five children under eight years. It was closed in 1988 and is now a nursing and residential home.

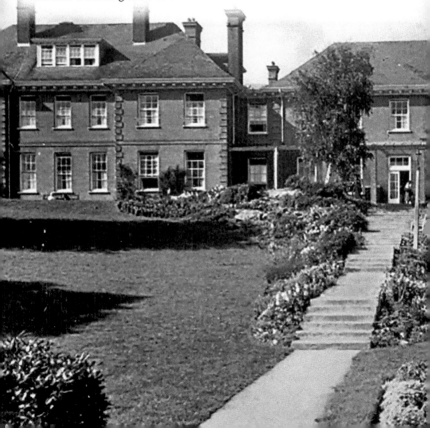

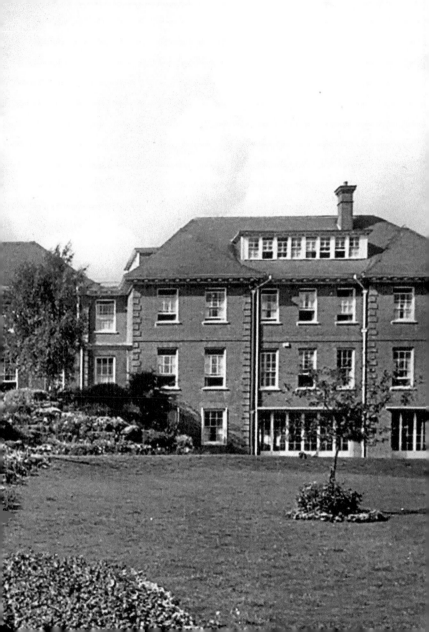

21. HYTHE STATION

The station is pictured shortly before its closure on 1 December 1951. The branch to Hythe and Sandgate was opened by the South Eastern Railway on 9 October 1874 and was envisaged as a through route to Folkestone Harbour. However, opposition in Folkestone killed off the extension plan and the branch settled down to become a quiet backwater. The station has disappeared under new housing, but the stationmaster's house in Cliff Road (inset) can still be seen.

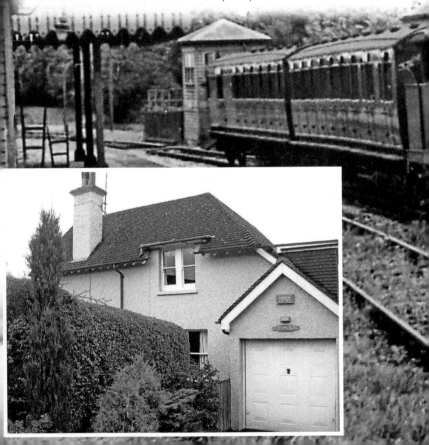

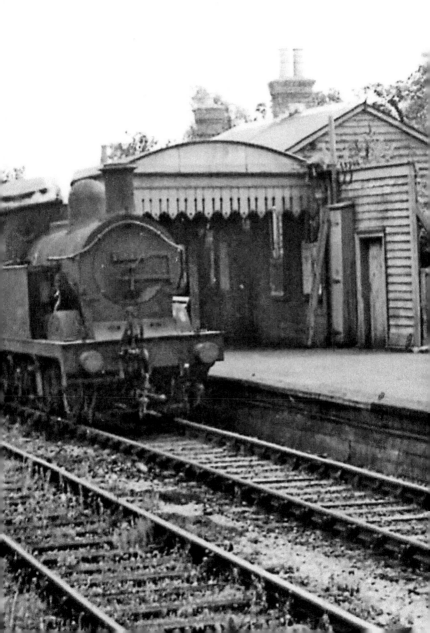

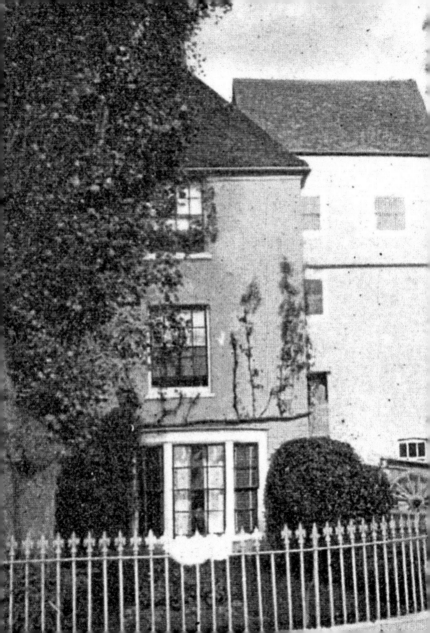

22. WATERMILL

The Grade II-listed watermill in Mill Lane was built in 1772 and became known as Burch's Mill following its acquisition by George Burch in 1832. The mill stands astride the Saltwood Brook and has a 21-foot-diameter overshot waterwheel and four pairs of milling stones. An auxiliary steam engine was added in the mid-nineteenth century after the millpond had begun to silt up. Restoration work to the mill was carried out in the 1980s and 1990s.

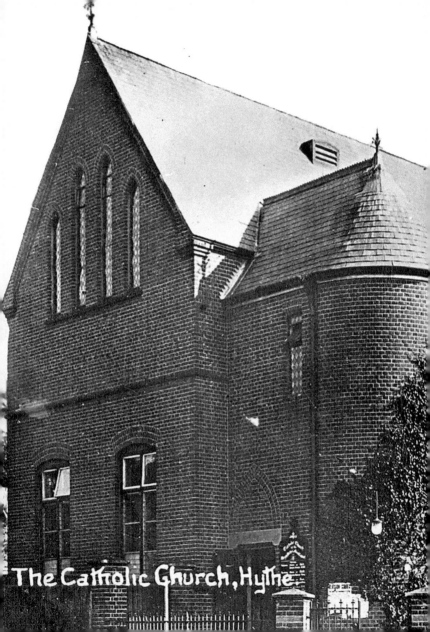

The Catholic Church, Hythe

23. CATHOLIC CHURCH

The first Catholic Mass house was opened in Hythe in 1854 by Father Chevalier, but from 1867 to 1891 the town was without a priest and worshippers had to go to Folkestone. Father Selley established the Augustinian presence in Hythe in 1891 and gave public Masses; however, it was his successor, Father Richard O'Gorman, who built the church – on the corner of Lower Blackhouse Hill and Mill Lane, on 6 August 1894.

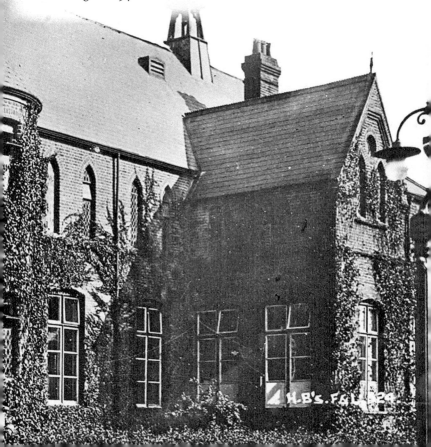

24. THE BELL

The Bell is one of Hythe's oldest inns and still looks much the same as on this Edwardian advertising card. The weatherboarding exterior is said to have been salvaged from wrecked vessels. The inn is well known for its past smuggling connections and houses an old tunnel through which casks of brandy and rum were floated to the watermill behind. In 1963 two skeletons, thought to have been victims of murder, were discovered concealed behind the fireplace.

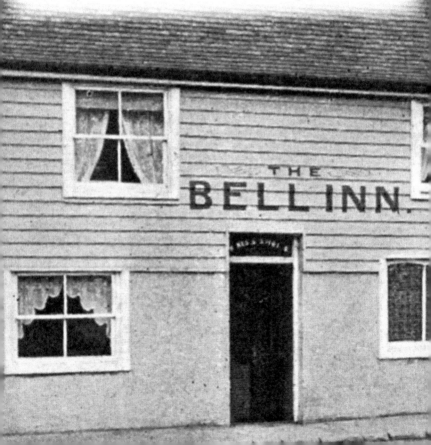

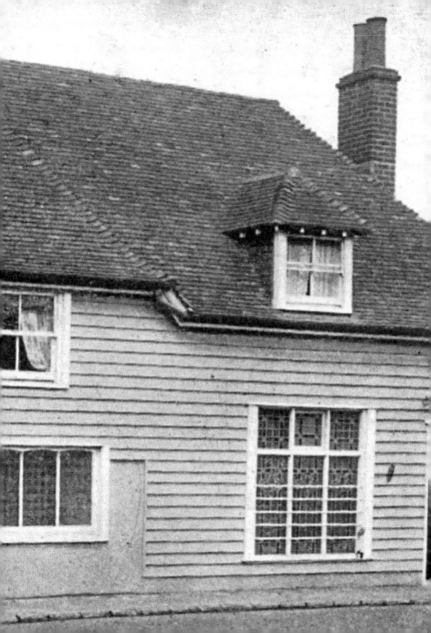

25. RITZ CINEMA

The art deco Ritz Cinema was opened on the corner of Prospect Road and East Street on 12 June 1937 and could seat 858 people. In 1971 falling attendances led to the building being converted to a bingo hall, although a small cinema (seating 276) was retained in the circle. However, the Ritz was finally closed on 7 August 1984 and was demolished to make way for the Blythe Court complex of apartments.

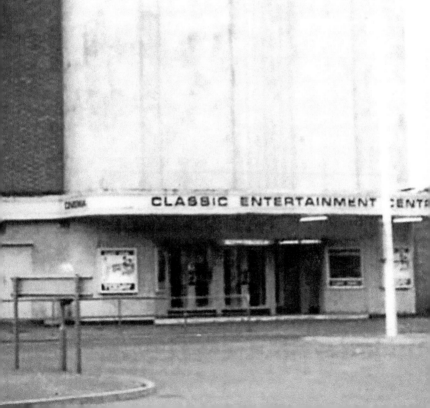

26. ROYAL MILITARY CANAL

The Royal Military Canal was constructed for 28 miles from Seabrook to Pett Level, near Hastings, between 1804 and 1809 as a Napoleonic defensive measure. The canal was dug to a depth of 9 feet and is 62 feet wide at Hythe. Every 600 yards the canal was enfiladed to provide maximum firepower from batteries at each end and was additionally protected by a bank and ditch. It is now one of Hythe's most attractive features.

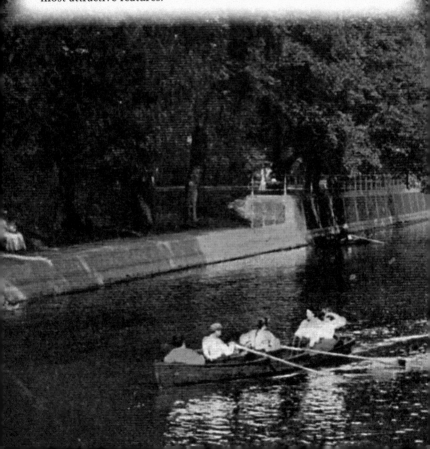

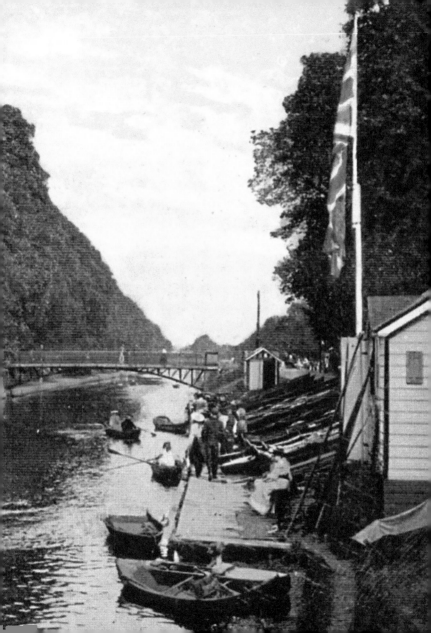

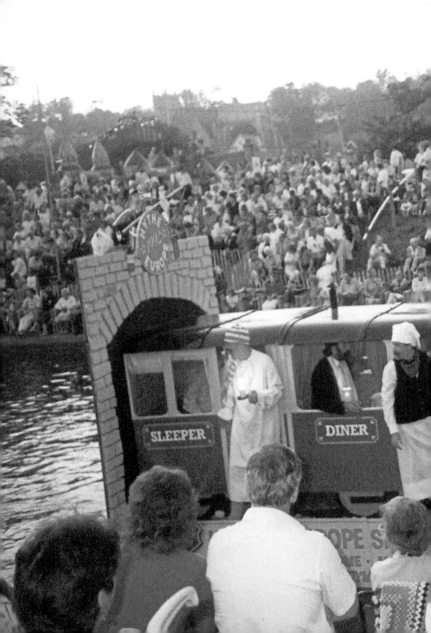

27. VENETIAN FÊTE

Boating is a popular feature of the canal during the summer months and the Venetian Fête is a renowned Hythe attraction that was established in 1860 as part of Hythe Cricket Week. With its procession of colourfully decorated craft and trees lining the canal festooned with fairy lights and Chinese lanterns, the fête grew to be a feature of Hythe's summer season. Since 1955 the event has been biennial, alternating with the Hythe Festival.

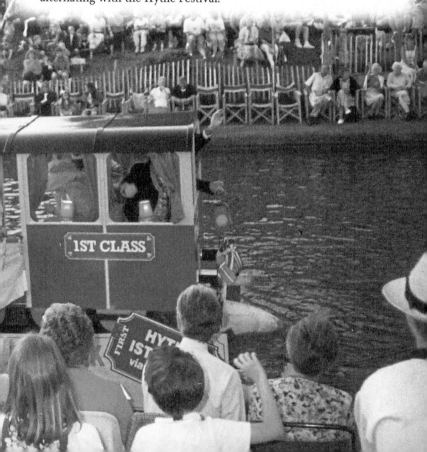

28. THE GROVE

The Grove is an attractive area of flower beds and trees bordering the Royal Military Canal and featured a bandstand and the town's war memorial. Sadly, many of the trees succumbed to Dutch elm disease in the 1970s and the bandstand was burnt down. The war memorial, designed by Gilbert Bays and unveiled by Earl Beauchamp on 16 July 1921, thankfully remains and records Hythe's 154 civilian casualties of the First World War and the sixty-three from the Second World War.

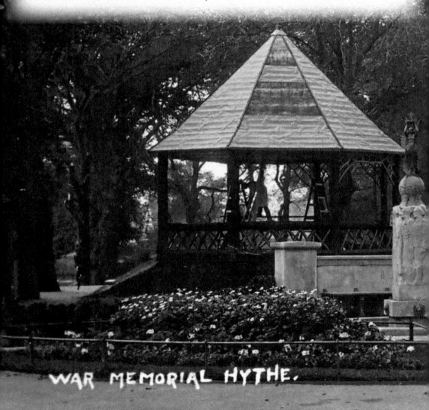

WAR MEMORIAL HYTHE.

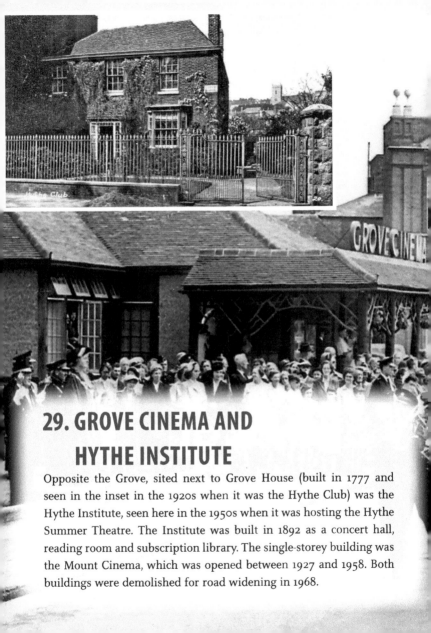

29. GROVE CINEMA AND HYTHE INSTITUTE

Opposite the Grove, sited next to Grove House (built in 1777 and seen in the inset in the 1920s when it was the Hythe Club) was the Hythe Institute, seen here in the 1950s when it was hosting the Hythe Summer Theatre. The Institute was built in 1892 as a concert hall, reading room and subscription library. The single-storey building was the Mount Cinema, which was opened between 1927 and 1958. Both buildings were demolished for road widening in 1968.

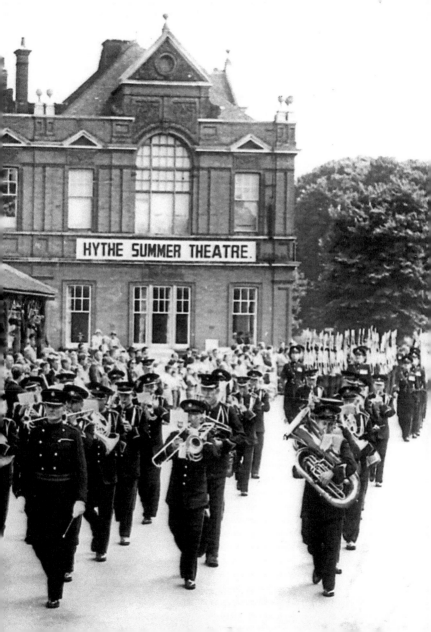

30. LADIES WALK

Ladies Walk is an attractive tree-lined thoroughfare that leads from the Royal Military Canal to South Road and was laid out in 1810 to commemorate the Golden Jubilee of George III. The walk was a fashionable promenade during the Victorian and Edwardian periods, particularly for Church Parade, where the wealthy strolled along it after Sunday service showing off all their finery. It has alternatively been called Marine Walk and Lover's Walk.

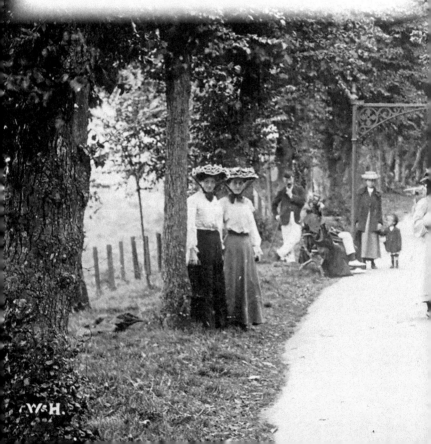

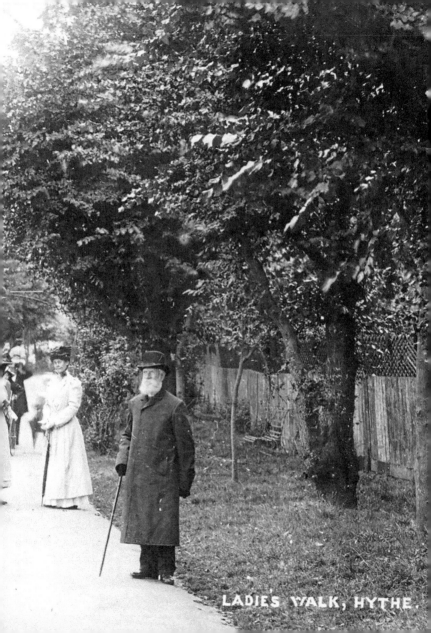

LADIES' WALK, HYTHE.

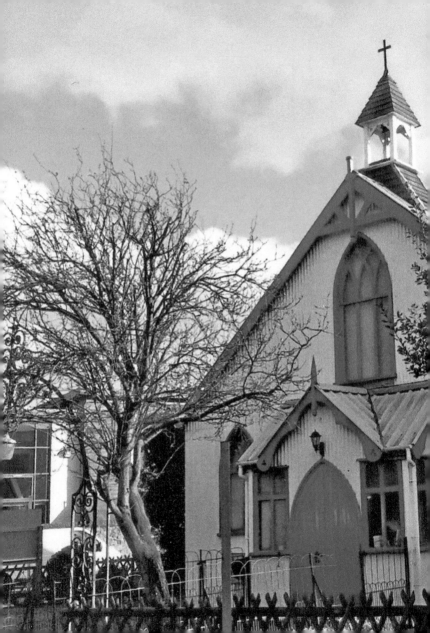

31. TIN TABERNACLE

Erected on a triangular site at the junction of Stade Street and Portland Road, the Grade II-listed Tin Tabernacle is a rare survivor of the prefabricated corrugated-iron church buildings erected towards the end of the Victorian era. Opened on 19 September 1893 as the Mission Church, the building was lovingly restored and reopened on 30 May 2014 by John and Kay Keesing as an event and exhibition space for the local community.

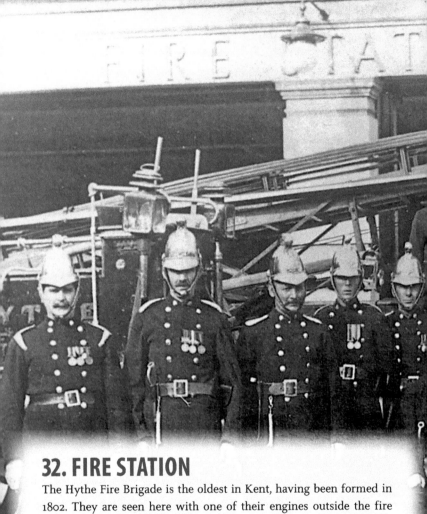

32. FIRE STATION

The Hythe Fire Brigade is the oldest in Kent, having been formed in 1802. They are seen here with one of their engines outside the fire station in Portland Road after it had been reconstructed in 1925. The brigade was originally volunteer-led and remained independent until absorbed into the Kent Fire Brigade in 1948. With a new station having been built in Wakefield Way, the old building is now Hythe Garage.

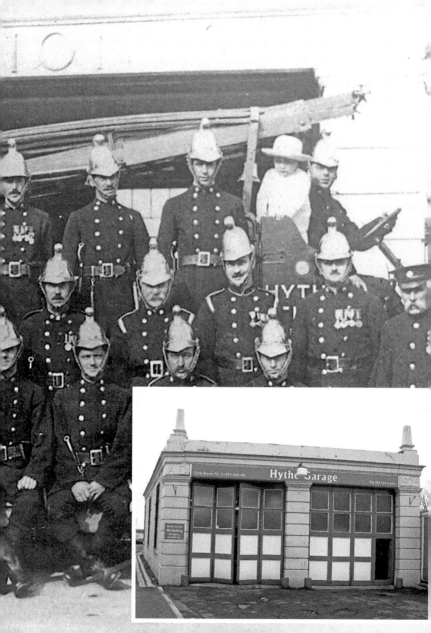

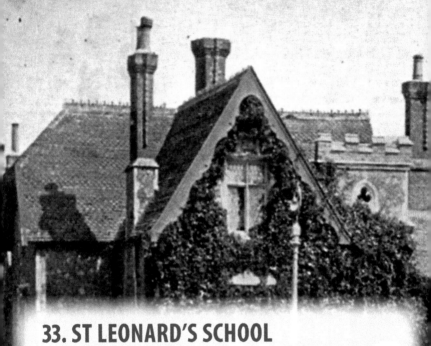

33. ST LEONARD'S SCHOOL

The Hythe National School, later St Leonard's Church of England School, was founded in July 1814 at Captain Robinson Beane's house in the High Street, and eighty-two boys were admitted after their parents paid 1d for a week's schooling. Girls were admitted from 1817. A new purpose-built school was opened on 2 December 1851 in St Leonard's Road, but in 2005 the decision was taken to incorporate it into the new Hythe Bay School in Cinque Ports Avenue and the building was converted to residential use.

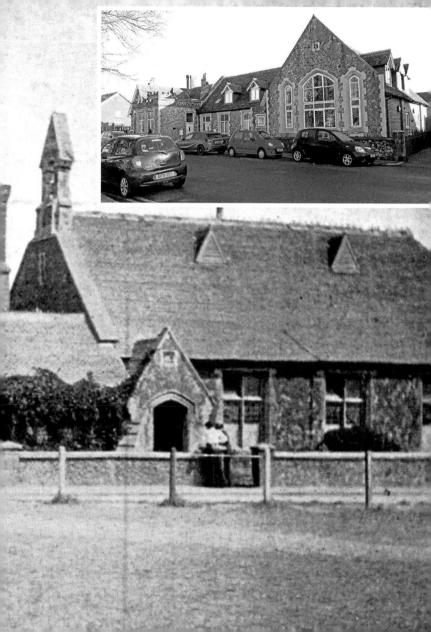

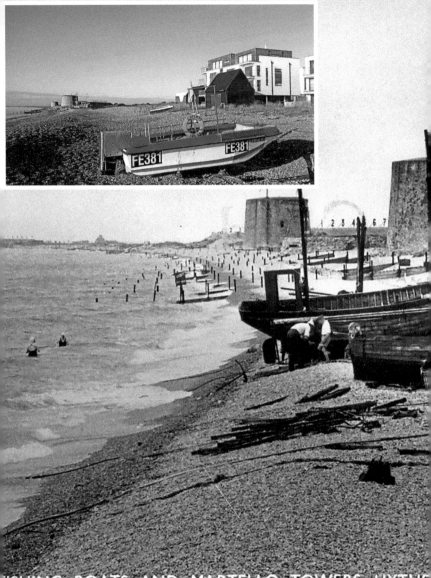

FISHING BOATS AND MARTELLO TOWERS, HYTHE

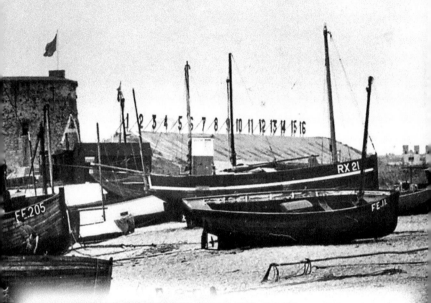

34. FISHERMAN'S BEACH AND HYTHE RANGES

Fisherman's Beach, pictured with Martello tower Nos 14 and 15 on Hythe Ranges, is home to Hythe's small collection of fishing craft. The inset photo shows the apartments that have recently been built on the edge of the beach. The Martello towers were another Napoleonic defence measure. Twelve were built in Hythe, of which only three remain intact. Hythe Ranges, established to train those based at the School of Musketry, are still used by the Army.

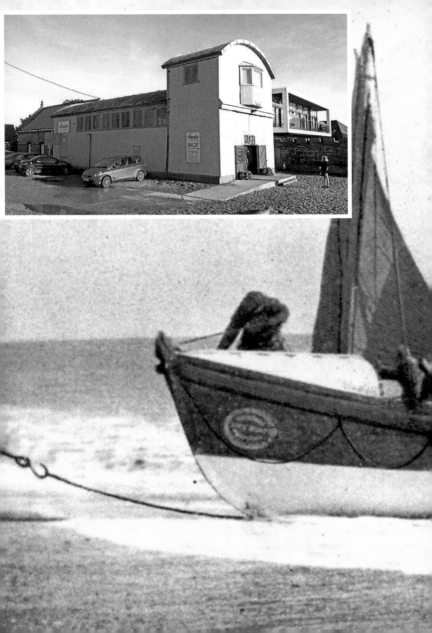

35. HYTHE LIFEBOAT

The Hythe lifeboat was transferred to the Fisherman's Beach from
Seabrook in 1893 and a lifeboat house was erected at a cost of £570.
The lifeboat seen in this postcard view is *Meyer de Rothschild (II)* –
on station between 1884 and 1910 with a record of twenty-seven lives
rescued from twenty launches. The lifeboat service was discontinued
in 1940 but both the old and new stations survive and can be seen in
the modern photograph.

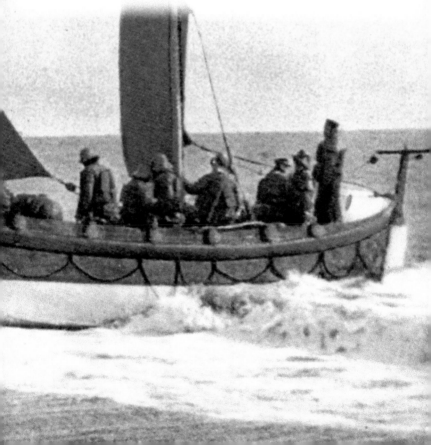

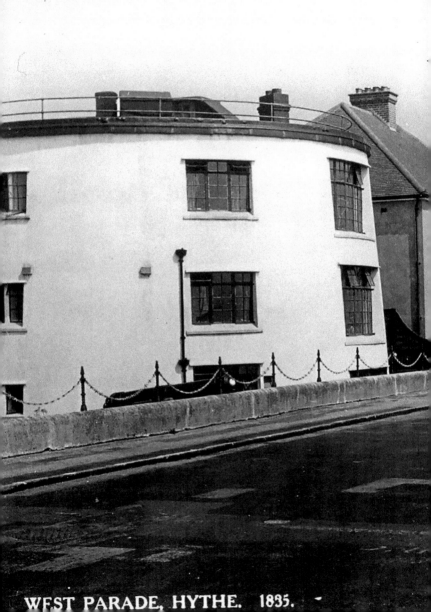

WEST PARADE, HYTHE. 1835.

36. MARTELLO TOWER ON WEST PARADE

This is Hythe's other surviving Martello tower – No. 13 – which was converted into a house in 1928. Between 1805 and 1810, seventy-four south coast towers were built between Folkestone and Seaford. In addition, Hythe received three forts – Twiss, Sutherland and Moncrieff – none of which survive. This postcard from the 1930s shows the newly built houses adjoining the tower, although the gap between them and the Victorian terraces was not closed until 1998.

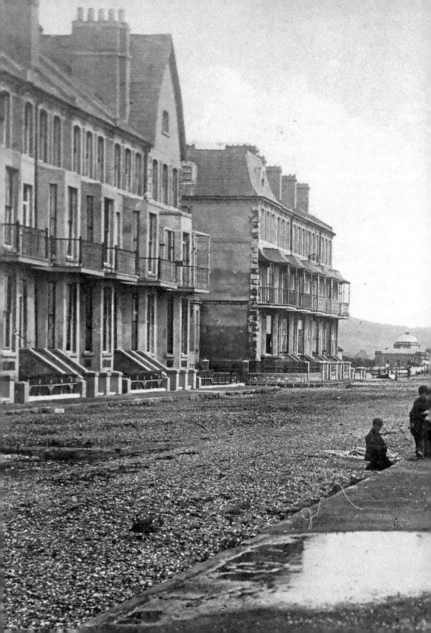

37. WEST PARADE

West Parade, seen here in August 1900 following a rain shower, was developed along with Marine Parade and Princes Parade as seafront promenades as part of Hythe's attempt to join the realms of seaside resorts, which were growing fast during the Victorian era. West Parade was laid out in 1889–90 and was furnished with Ormonde Terrace (nearest the camera) and Rostrevor Terrace, both typically elegant Victorian bow-fronted houses. In the distance are the Pavilion and Moyle Tower.

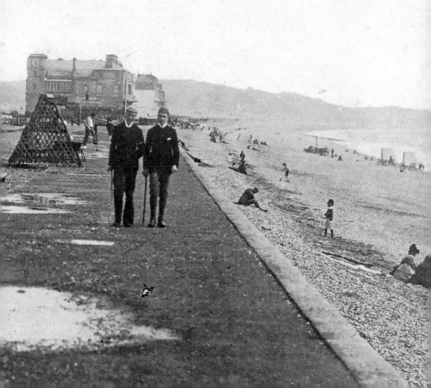

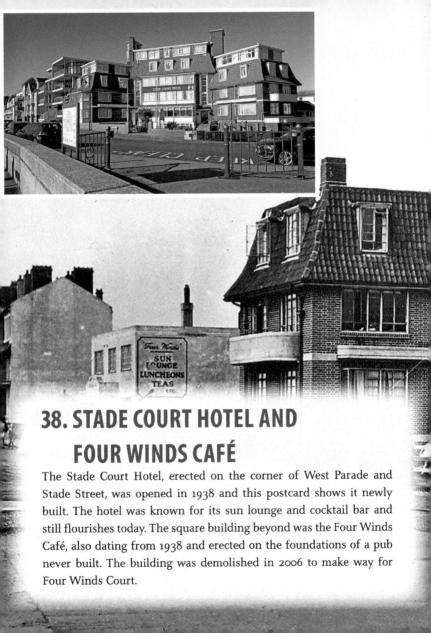

38. STADE COURT HOTEL AND FOUR WINDS CAFÉ

The Stade Court Hotel, erected on the corner of West Parade and Stade Street, was opened in 1938 and this postcard shows it newly built. The hotel was known for its sun lounge and cocktail bar and still flourishes today. The square building beyond was the Four Winds Café, also dating from 1938 and erected on the foundations of a pub never built. The building was demolished in 2006 to make way for Four Winds Court.

39. STADE STREET

Stade Street is the main thoroughfare between the town centre and the seafront, and this 1930s view is looking down the street from the seafront towards the town centre. The building on the left is Sutherland House, a large boarding house with forty bedrooms and its own lock-up garages. It was closed in 1981 and is now flats. The empty plot on the opposite corner, at the junction with South Road, is now covered by the Captain's Court apartments.

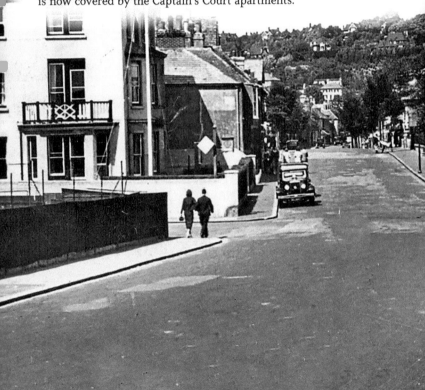

Stade Street, Hythe.

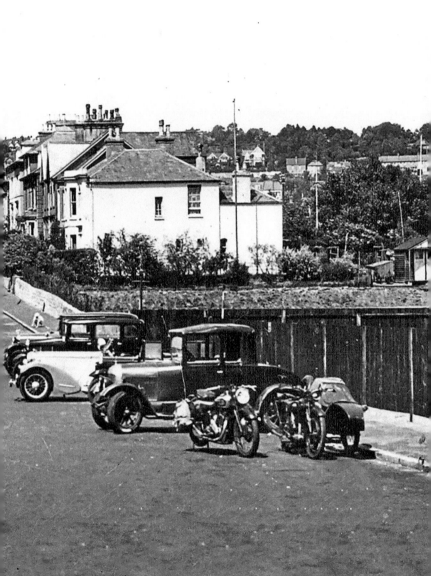

40. FLOODING, 1877

Hythe has suffered its fair share of dramatic moments, such as on 1 January 1877 when a great storm led to the sea reclaiming all the land up to the Royal Military Canal by breaking through temporary sea defences. Two bridges across the canal were destroyed. This view is looking along an undeveloped South Road from Stade Street and shows the Pavilion and Moyle Tower on the seafront. In Stade Street, many householders had to be rescued from upstairs windows.

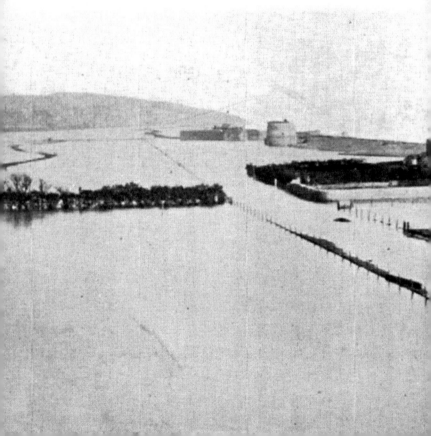

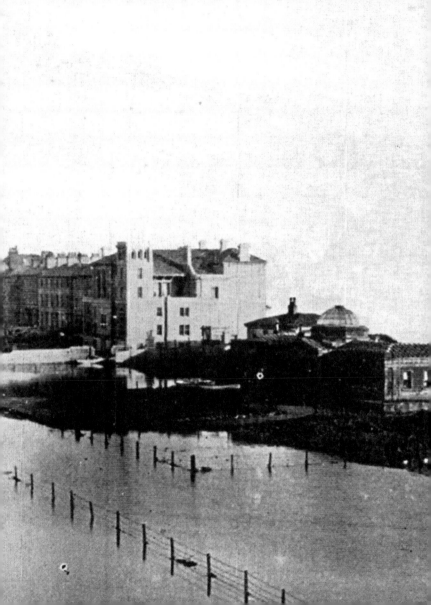

41. TOP OF STADE STREET AND MARTELLO TOWER NO. 12

This rare photograph from the 1870s shows short-lived properties in Stade Street near the seafront. The empty plot on the right of the photograph 39 shows that they had already been demolished by the 1930s. Also long gone is Martello Tower No. 12, which was demolished soon after this view was taken. Nos 10 and 11 (the latter can be seen in the 1877 flooding photo) also perished at the same time.

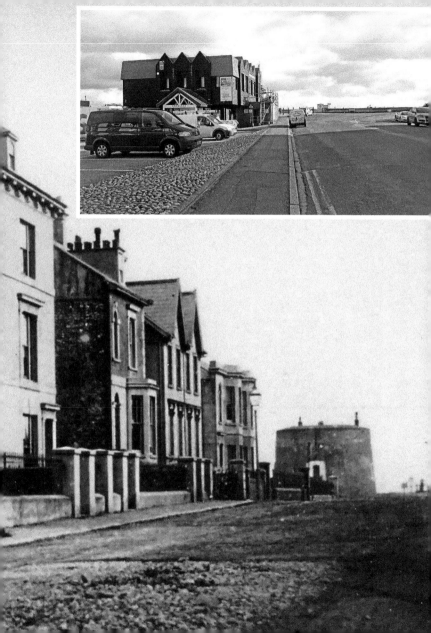

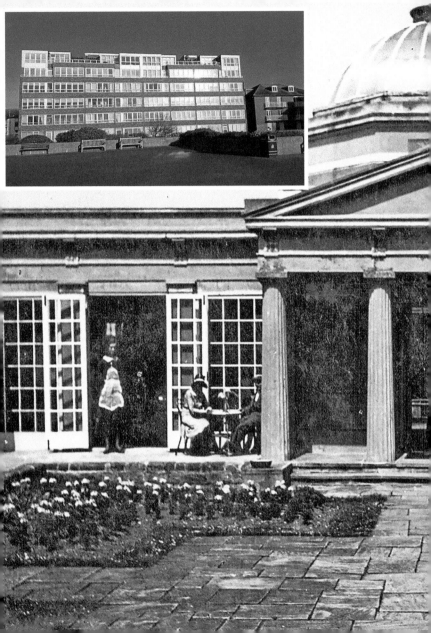

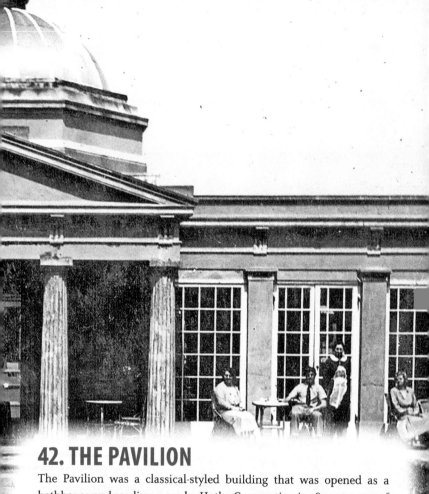

42. THE PAVILION

The Pavilion was a classical-styled building that was opened as a bathhouse and reading room by Hythe Corporation in 1854 at a cost of £2,000. The baths catered for those who believed that the bathing and drinking of seawater would cure all their ills. By the time of this 1920s view it was being used as a tearoom and restaurant. The Pavilion closed in 1953 and was demolished, and flats now cover the site.

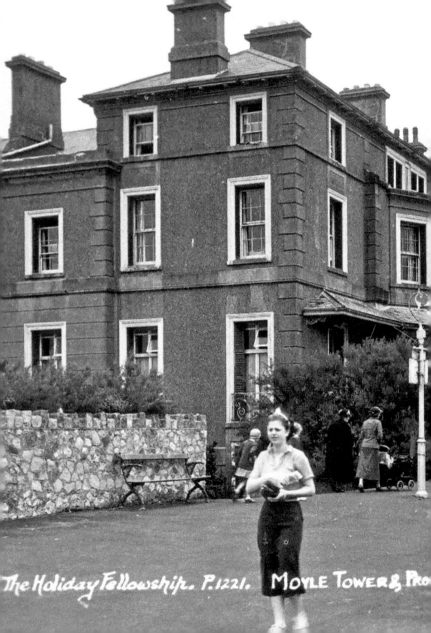

The Holiday Fellowship. P.1221. MOYLE TOWER & Pro

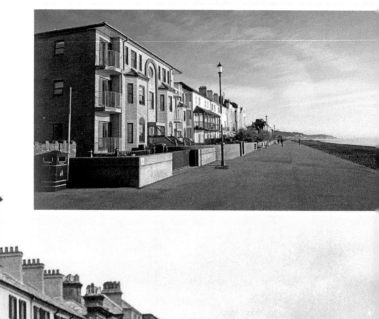

43. MOYLE TOWER

Moyle Tower was a prominent feature of Marine Parade before it was demolished in the 1980s to make way for a block of flats. Completed as a residence in the 1870s after it had been left as a half-built hotel, it passed to the Holiday Fellowship in 1923 and was used as a Christian holiday centre. The Fellowship issued their own postcards of the centre and this view is from the 1930s.

ENADE, LOOKING EAST. (2) Hythe Centre.

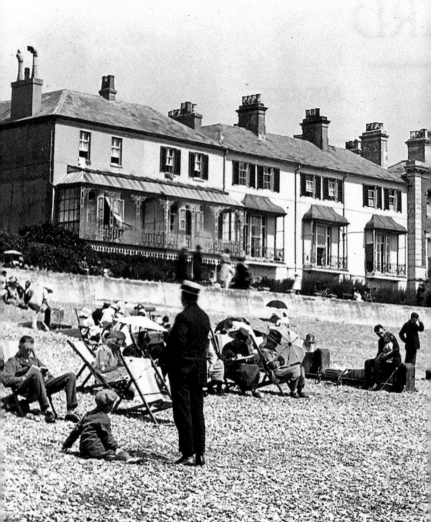

44. BEACH AND MARINE PARADE

Hythe Beach and Marine Parade pictured on a sunny day in the 1930s with the deck chair attendant in evidence collecting his fares. The buildings in the background, originally known as the Marina, were erected in the 1870s as seaside residences and boarding houses when 300 feet of promenade and sea wall were laid out by Hythe Corporation in association with the Hythe Land and Building Investment Company. A terrace of balconied properties, known as Saltwood Gardens, was erected at the same time.

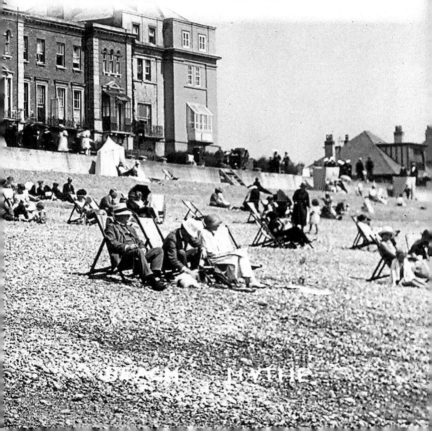

45. BEACONSFIELD TERRACE

A boy and girl pose for local photographer John Charles Savage in the 1930s for his postcard of the Beaconsfield Terrace – seen in the background. The terrace, at the far end of Marine Parade, was erected in two sections during the 1880s on the site of Fort Twiss and was named in honour of Lord Beaconsfield, otherwise known as Benjamin Disraeli. The house in the foreground had just been built when the photograph was taken.

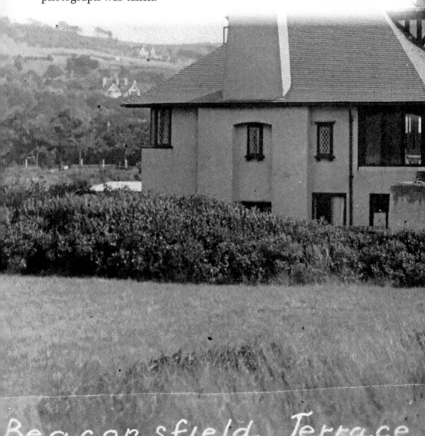

Beaconsfield Terrace.

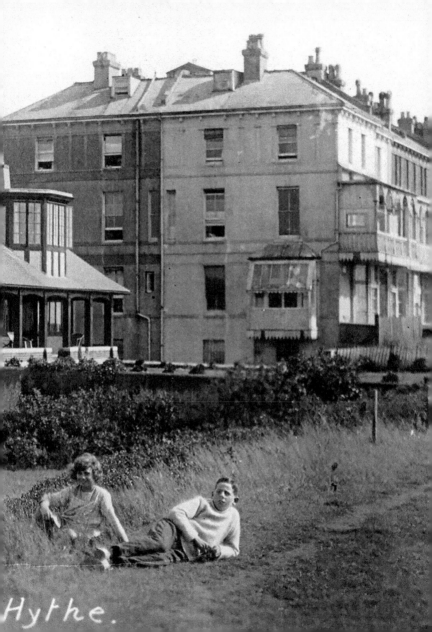

Hythe.

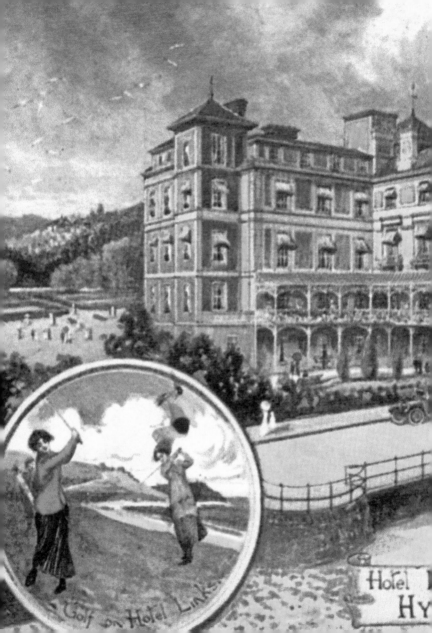

Golf on Hotel Links

Hotel
Hy

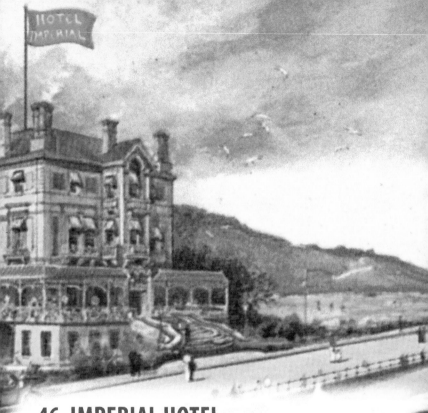

46. IMPERIAL HOTEL

The Seabrook Hotel was erected by the South Eastern Railway at a cost of £30,000 and was officially opened on 21 July 1880. The hotel was planned as part of the exclusive Seabrook Estate, which was never built. In 1896 it was enlarged and five years later was acquired by the Hythe Imperial Hotel Co., led by William Cobay, who renamed it and issued this advertising card in around 1910. Both the hotel and its golf course are still flourishing.

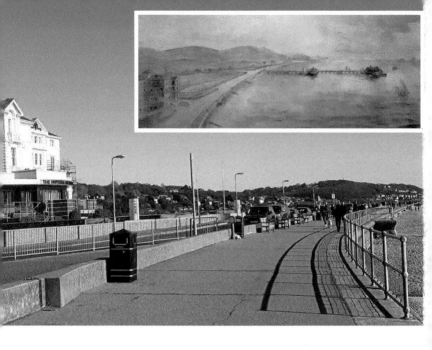

47. PRINCES PARADE AND PLANNED PIER

The 6,000-foot-long Princes Parade was opened from the Imperial Hotel to the Sandgate boundary on 15 October 1881 in anticipation of the development of the Seabrook Estate. This was never built, and neither was this proposed pier, which was designed by Sir John Coode and for which a Provisional Order to build it was granted in March 1882. The pier would have been 640 feet long and would have had a bandstand, pavilion and landing stage.